GOOD JOKES BAD DRAWINGS

Christine Vineyard

Fulton Books, Inc.
Meadville, PA

Published by Fulton Books 2021

ISBN 978-1-64952-597-0 (paperback)
ISBN 978-1-64952-624-3 (hardcover)
ISBN 978-1-64952-598-7 (digital)

Printed in the United States of America

what is a vampire's favorite fruit?

blood orange

why didn't the orange win the race?

it ran out of juice.

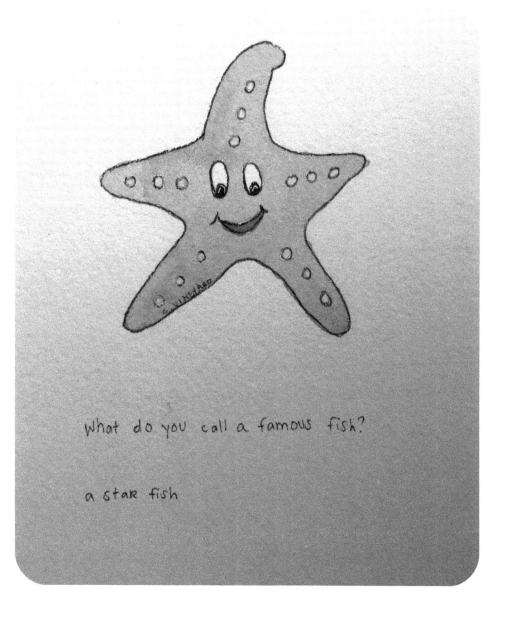

what do you call a famous fish?

a star fish

What did the big chimney say to
the little chimney?

you're too young to smoke

i'm reading a book about anti-gravity

it's impossible to put down

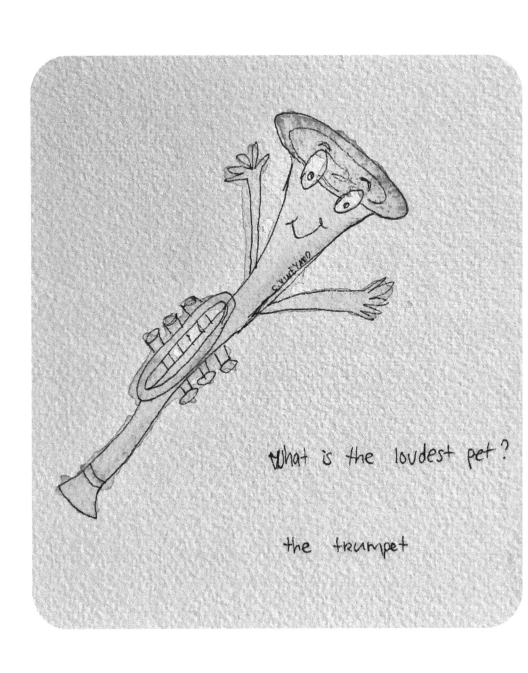

What is the loudest pet?

the trumpet

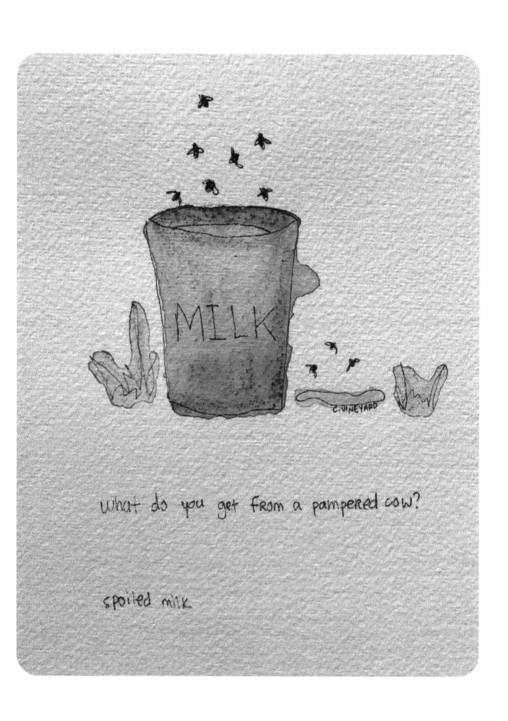

what do you get from a pampered cow?

spoiled milk

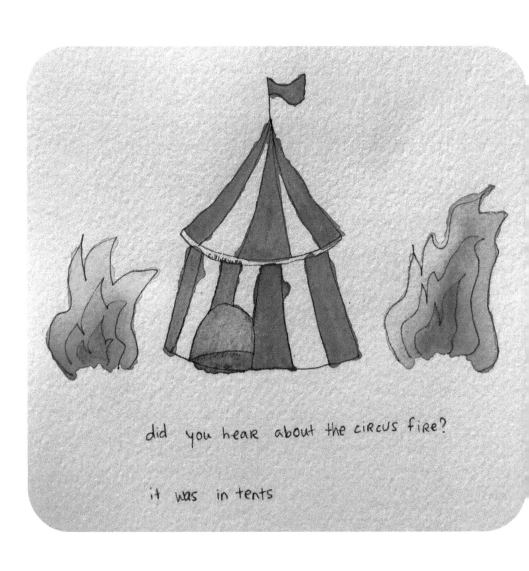

did you hear about the circus fire?

it was in tents

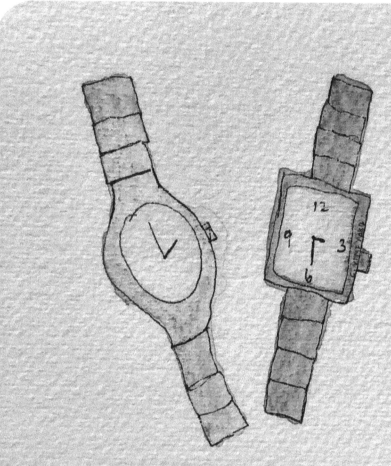

my uncle named his dogs Rolex and timex. they're his watch dogs.

What did the baby corn ask the mother corn?

where's popcorn?

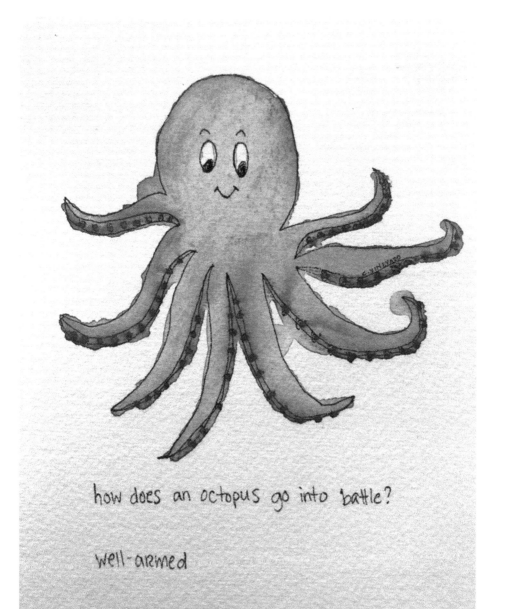

how does an octopus go into battle?

well-armed

what are pilgrims favorite music?

plymouth ROCK

why do bears wear fur coats?

because they look silly in sweaters

What does a thesaurus eat for breakfast?

synonym Rolls

what letters are not
in the alphabet?

the ones in the mail

Why do porcupines always win the game?

they have the most points.

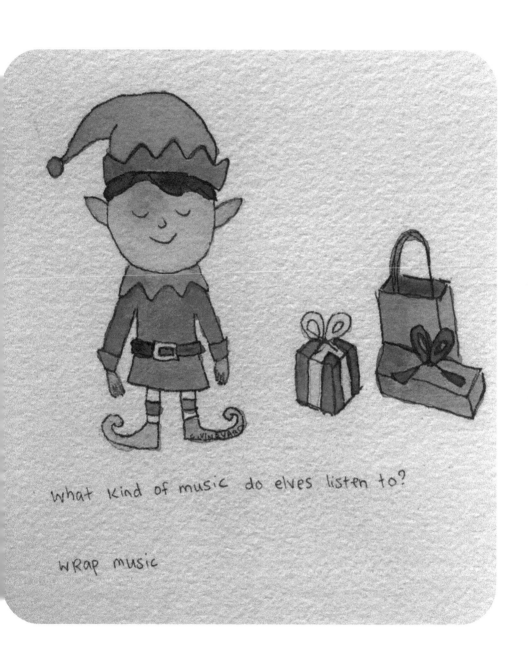

What kind of music do elves listen to?

wRap music

What did the stamp say to the envelope?

i'm stuck on you

What do vampires
give you in the winter?

frostbite

what is the coldest country?

chile

what do you call a snake in a bakery?

a pie-thon

What do you call an older snowman?

water

what are the
strongest days
of the week?

Saturday and Sunday.
Every other
day is a
weak day.

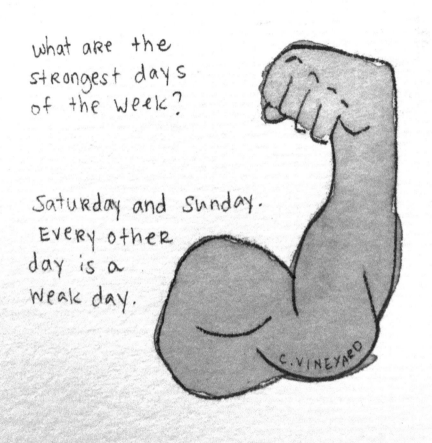

What kind of tree fits
in your hand?

a palm tree

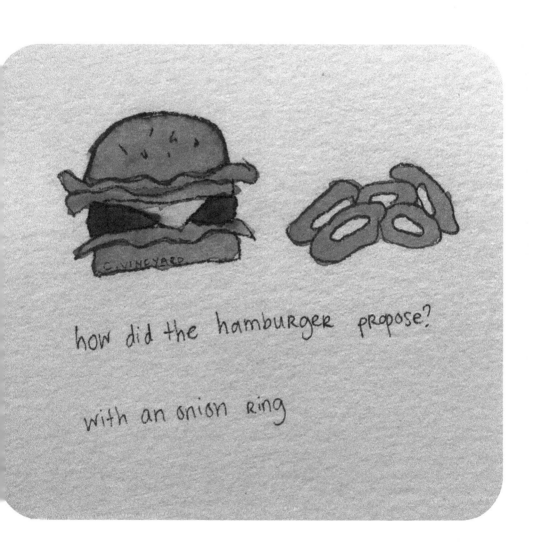

how did the hamburger propose?

with an onion ring

why was six scared of seven?

because seven ate nine.

where do elephants pack their clothes?

in their trunks

how do you stop an elephant from charging?

take away it's credit cards

why do fish swim in saltwater?

because pepper makes them sneeze

why did the tree go to the dentist?

to get a root canal

what did the dalmation say after lunch?

that hit the spot

how do you make gold soup?

put 24 carrots in it

Why was there thunder and lightening in the classRoom?

they were brainstorming.

What kind of car does
Mickey Mouse's girlfriend
drive?

a minnie van

how do turtles talk to each other?

shell phones

what's black, white, and red all over?

an embarrassed zebra.

What do you call a pig
that knows karate?

pork chop

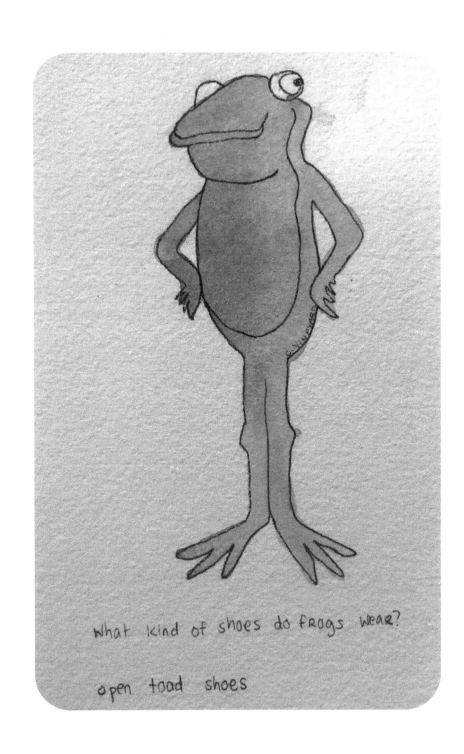

What kind of shoes do frogs wear?

open toad shoes

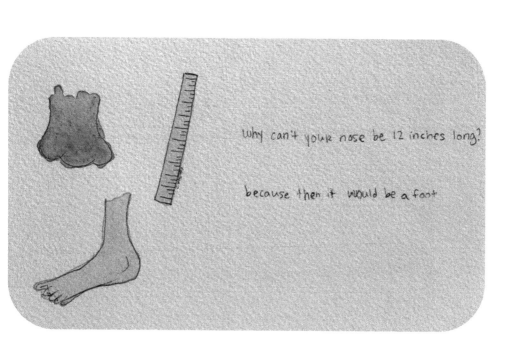

why can't your nose be 12 inches long?

because then it would be a foot

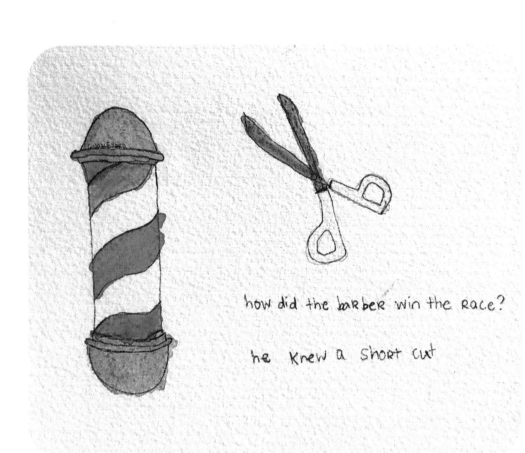

how did the barber win the race?

he knew a short cut

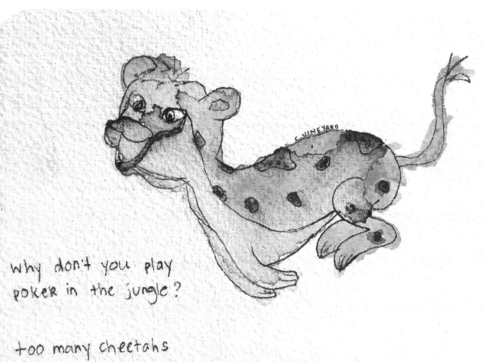

why don't you play
poker in the jungle?

too many cheetahs

where do boats go when they get sick?

the dock

why did the robber take a bath?

because he wanted to make a clean getaway

What do lawyers wear
to court?

lawsuits

Which dinosaur knows the most words?

the thesaurus

why was the fish in detention?

he got caught with seaweed

where do you learn how to
make ice cream?

sundae school

why did the tomato blush?

because it saw the salad dressing

why can't you hear a
pterodactyl go to the
bathroom?

because the pee is silent

what do you call a sleeping bull?

a bull-dozer

Why did the golfer wear two
pairs of pants?

in case he got a hole in one.

why is corn such a good listener?

because it's all ears

what did the traffic light
say to the car?
don't look! i'm changing

Why was the duck
arrested?

it was suspected of
fowl play

what did the teddy bear
say when he was offered
dessert?

No thanks, i'm stuffed

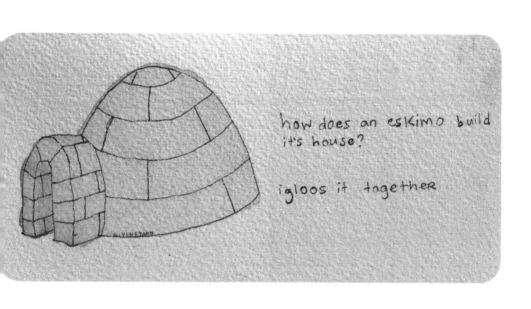

how does an eskimo build
it's house?

igloos it together

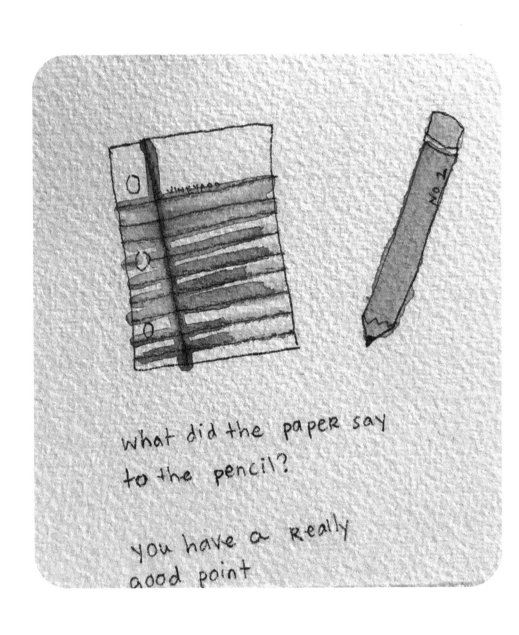

where do hamburgers dance?

the meat ball

why did the cookie go to the doctor?

because it felt crummy

when is a door not a door?

When it's a jar

how do you make a kleenex dance?

put a little boogie in it.

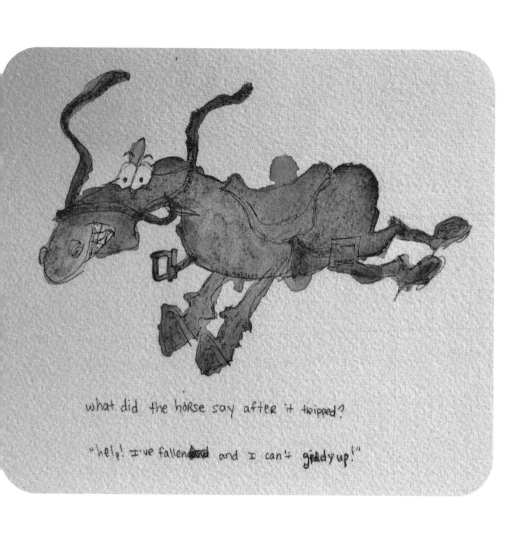

what did the horse say after it tripped?

"help! I've fallen~~and~~ and I can't ~~giddy~~ up!"

a ham sandwich walks into a bar and orders a beer.

the bartender says, "SORRY, we don't serve food here"

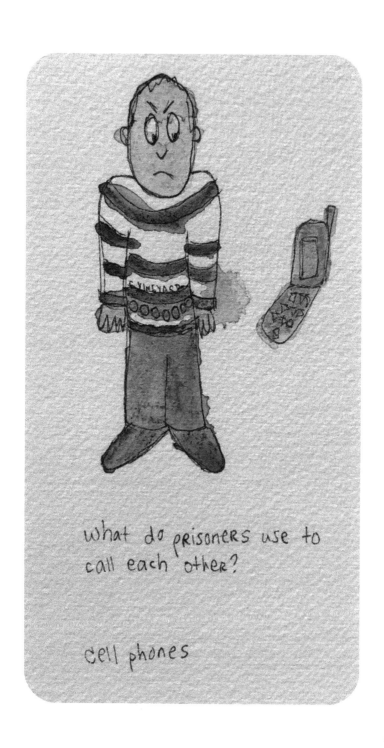

what do prisoners use to
call each other?

cell phones

what do you call a fake noodle?

an impasta

Why did the coffee file a
police report?

it was mugged

why don't melons get married?

because they canteloupe

why did the SCARECROW win an award?

because he was outstanding in his field

when does a joke become
a dad joke?

when it becomes apparent

i could tell a joke about pizza,
but it's a little cheesy

what do you call a fat psychic?

a four chin teller

parallel lines have so much in common. it's a shame they'll never meet

what do you call cheese that's
not yours?

Nacho cheese

why is a skeleton a bad liar?

you can see right through it.

how do you make an eggroll?

you push it down a hill

how does moses make tea?

hebrews it

have you heard about the
fire in the shoe factory?

hundreds of soles were lost

i owe a lot to the sidewalks. they've been
keeping me off the streets for years.

what did the buffalo say when he dropped off his kid at school?

bison

how do you make holy water?

you boil the hell out of it

did you know french fries weren't cooked in France?

they were cooked in Greece.

What does a house wear?

address

Why couldn't the bike stand up
by itself?

it was too tired

why did the painting go to jail?

because it was framed

What is the tallest
building in the
world?

the library because
it has so many
stories.

jokes about unemployed people
are not funny.

they just don't work

they're building a restaurant on Mars now. they're saying the food will be great, but worried about the lack of atmosphere.

this may come across as cheesy,
but i think you're grate

i cannot stand insect jokes.

they bug the heck out of me.

Stairs cannot be trusted.
they're always up
to something.

i'm looking for some good
fish jokes

if you know any, let minnow

why don't you want to go
to the bathroom with a pokemon?

because he'll pikachu

i heard a pretty juicy rumor
about butter, but i decided
not to spread it.

what time is it when you go to the dentist?

tooth-thirty

what do you call a cow
with three legs?

lean beef

what do you call a
woman with one leg?

eilean

what do you call a cow
with no legs?

ground beef

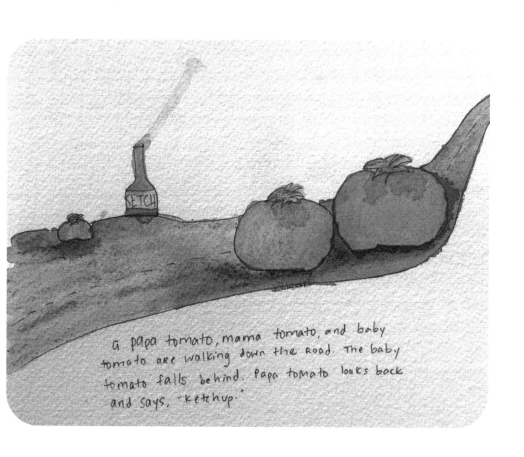

a papa tomato, mama tomato, and baby tomato are walking down the road. The baby tomato falls behind. Papa tomato looks back and says, "ketchup."

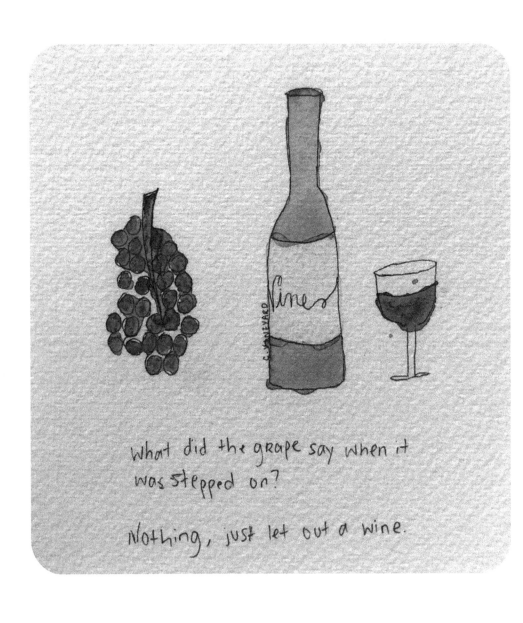

What did the grape say when it was stepped on?

Nothing, just let out a wine.

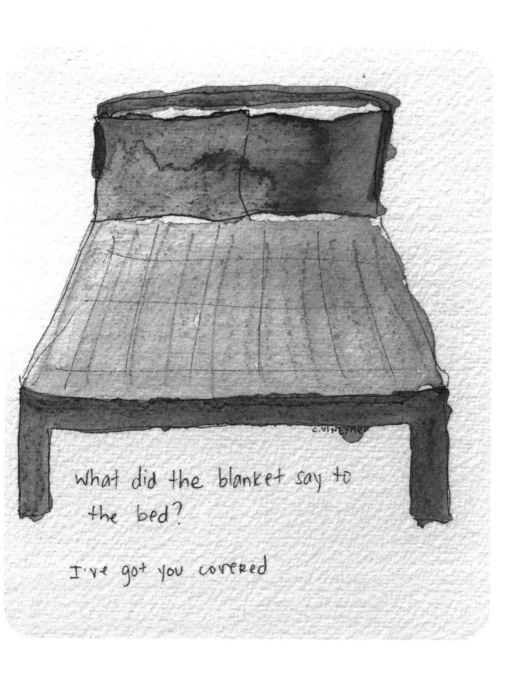

what did the blanket say to the bed?

I've got you covered

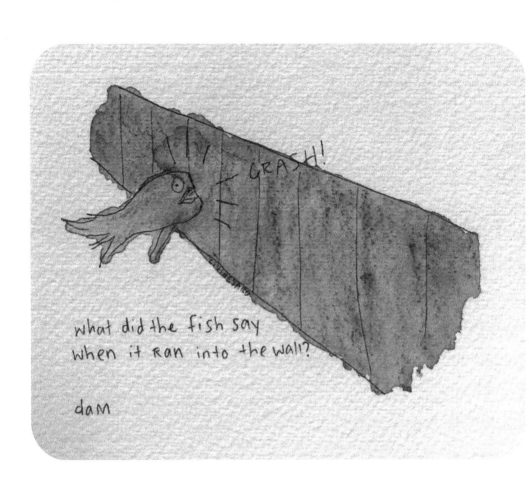

what did the fish say
when it ran into the wall?

dam

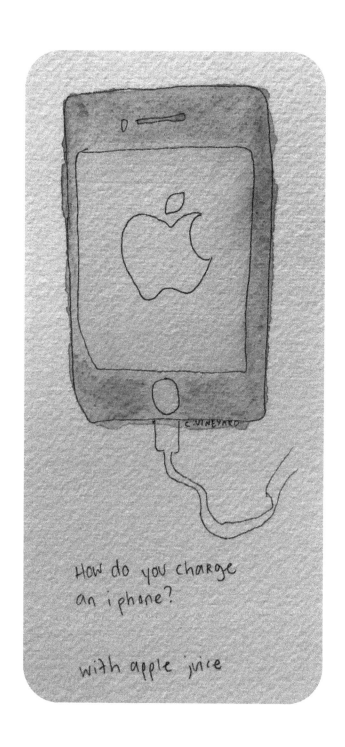

How do you charge
an iphone?

with apple juice

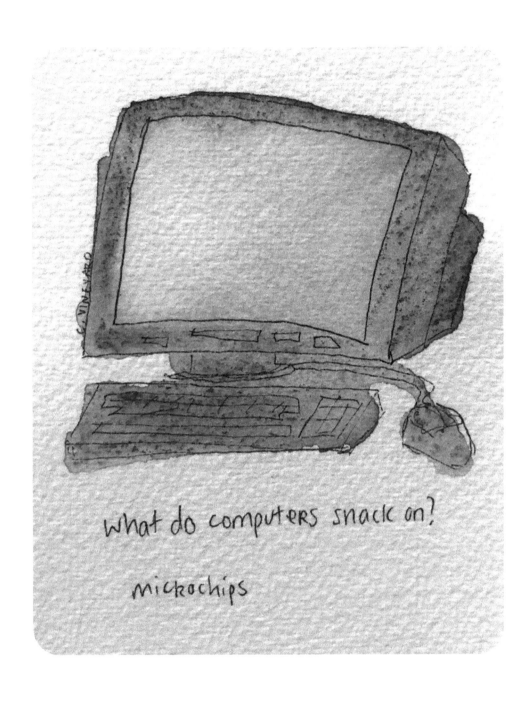

what do computers snack on?

microchips

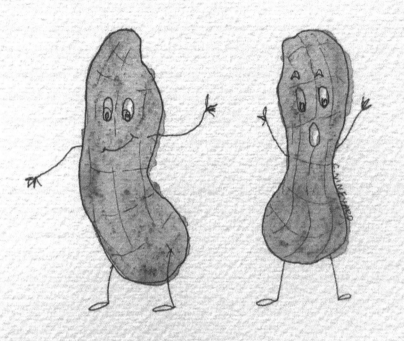

two peanuts are walking down the street
when one was a-salted.

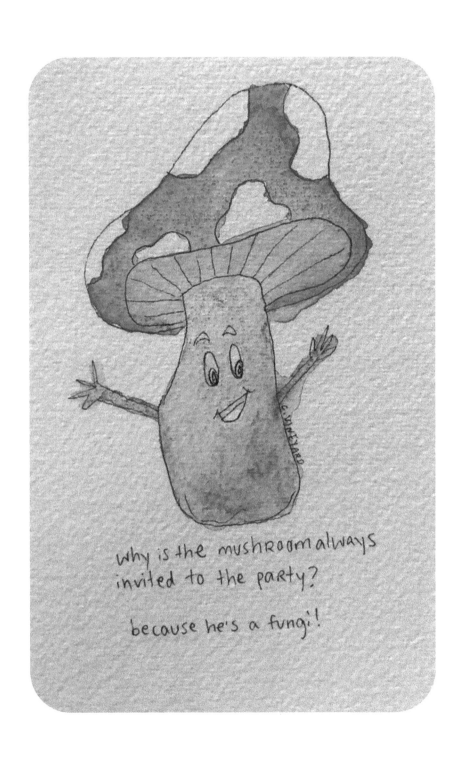

why is the mushroom always invited to the party?

because he's a fungi!

you're becoming a vegetarian?

i think that's a big missed steak.

What do you call a fish
with no eye?

fshhhhh

i once worked in a bank...

but then i lost interest

what did one hat say to another?

you stay here, i'll go on a head.

wanna hear a joke about construction?
never mind, i'm still working on it.

How come oysters never
donate to charity?

because they are shellfish.

what do you call an alligator wearing
a vest?

an investigator

what does a nosey pepper do?

it gets jalapeño business

if you ever get cold, just
stand in the corner of a room.
they're normally around 90 degrees.

Did you hear about the kidnapping at school? It's ok, he woke up.

Why can't you trust an atom?
because they make up everything

How do astronauts organize a party?
they planet

Why can't the leopard play
hide and seek?

because he was always
spotted.

what's the difference
between a guitar and
a fish?

you can tune a guitar,
but you can't tuna
steak.

What happens to a frog's car when it breaks down?
it gets toad away

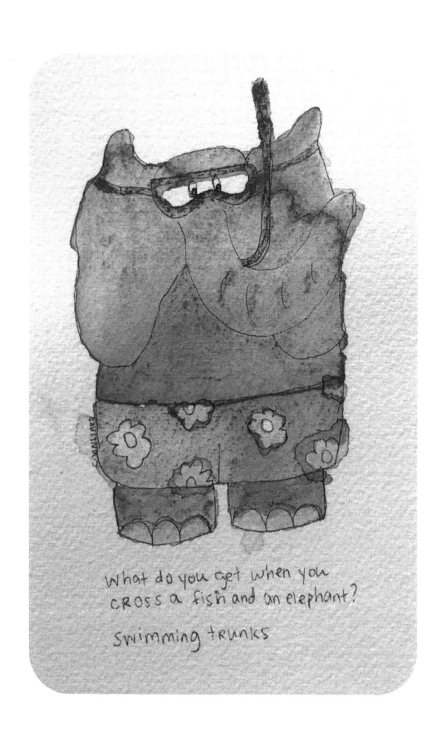

What do you get when you
cross a fish and an elephant?

swimming trunks

Why can't you tell an egg a joke?

because it will crack up

how do billboards talk?

sign language

what did the ocean
say to the shore?

nothing, it just waved

what's a skeleton's favorite
instrument?

a trombone

About the Author

Christine is an Atlanta native, born and raised, but relocated to Washington, DC, in 2011—an adopted second home. She's a visual artist, art teacher, and an aggressive traveler—using every opportunity available to hop on a plane and explore somewhere new. The more remote the location, the better, as she loves off-the-beaten-path kinds of adventures that would be hard to replicate. Her first trip overseas was to Tibet as a fifteen-year-old, and she's had the travel bug ever since. Christine loves people, animals (especially pups!), patterns, and conversations with strangers.

Christine is a relationship kind of gal, forming connections with her friends, family, students, and community. These relationships have shaped who she is and where her heart lies: with other people. A natural extrovert and giver (acts of service is one of her love languages), Christine thrives off other people's energy and never fails to see the magic each person holds inside.

Christine is the face behind Lidflutters, an online community where she shares her art, activism, travels, and humor. Speaking of humor, this girl loves cheese. The cheesier and cornier, the better! Feel free to connect with Christine through the Lidflutters community and share your own humor and jokes.

CPSIA information can be obtained
at www.ICGtesting.com
Printed in the USA
BVHW062010140521
607271BV00007B/671